TRADITIONAL
COOKING

ROME

FAVOURITE RECIPES

SIME BOOKS

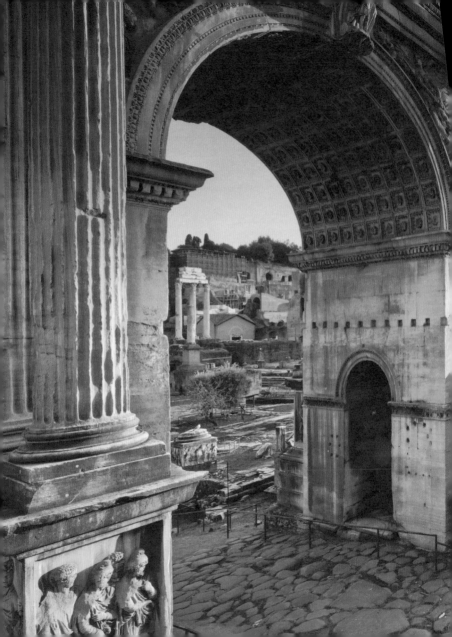

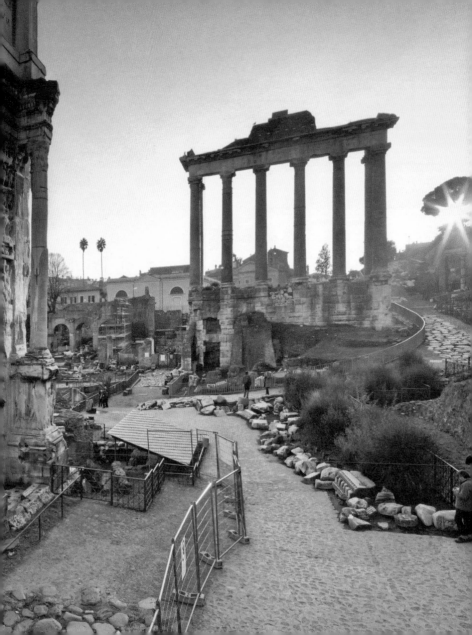

CONTENTS

Recipe difficulty:

■ ☐ ☐ easy

■ ■ ☐ medium

■ ■ ■ hard

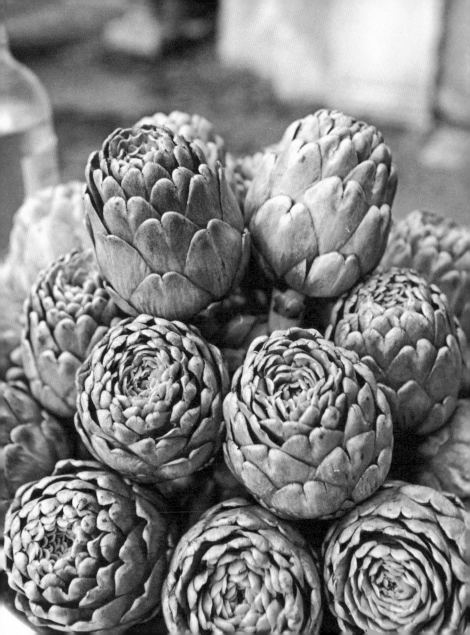

ROMAN CUISINE

Definitions for good cooking abound: there are those who define it an art, or a science, some call it the language of feeling and emotions that bring pleasure. Then there are those who say cuisine is not only eating but much more: it is poetry.

All these definitions are perfectly suited to Roman cuisine, in which colours and flavours interweave in a centuries-old tradition that preserves the goodness of the most authentic ingredients. The key to the recipes is the simplicity and only a unrefined palate would fail to grasp the extraordinary fragrances of such a generous land. Each dish begins with basic ingredients that combine pasta and meat, without neglecting vegetables, where chicory and chicory tips reign supreme, along with asparagus, broccoli and artichokes.

To describe Roman cuisine we can use the analogy of a symphony that opens with an *allegro* movement of appetizers, fragrant notes of fried dishes like anchovies, salt cod, artichokes and rice croquettes that preserve intact all the taste of Jewish cooking. Time and memory also survive in bruschetta, the triumph of basic ingredients, some served

with cockles, others as a crostino topped with spicy Pecorino cheese and sage, or with *provatura*, a young Provola cheese.

The symphony has just begun when solemn first courses arrive, those that intensify pleasure with "slow movements". There is no lack of choice: Roman menus vaunt spaghetti and rigatoni, tonnarelli cacio e pepe, pasta grìcia, gnocchi with shrimp and zucchini, penne arrabbiata, broccoli and skate soup, and iconic fettuccine alla papalina, which evoke a popular tradition in the Eternal City.

The main courses are a minuet, the third theme of this culinary symphony. Now is the time for meat and the best "motifs" excel with roast suckling lamb, chicken with peppers and the "fifth quarter", namely cattle or sheep leftovers that become tripe or offal. Peppers, broccoli, chicory and chicory tips, and artichokes are a constant, in many different recipes, and accompany the minuet with their endless aromas.

The symphony of Roman cuisine is destined to end, like all others, with the rondo, the dessert, the life and soul of every family meal: pears cooked in wine, apple cake, beignets,

castagnole and frappe, typical of Saint Joseph's Day and Carnival, alongside a ricotta and sour cherry tart.

And someone has even invented a "pupazza", a doll of honey paste that boasts three full breasts: two for milk and one for Castelli wines, which legend says would lull to sleep even the most restless children.

ANTIPASTOS

FRIED SALT COD FILETS

Serves 4:
- 400 g (14 oz) salt cod
- 100 g (1 cup) flour
- mineral water
- oil for frying
- salt
- pepper

Soak the salt cod for 1–2 days in water to desalt it, making sure to change the water every 8 hours.

Clean the cod, removing skin and bones. Filet and dry carefully.

Prepare the batter in a bowl, pouring in the flour and then drizzling in the cold water, whisking well and adding a pinch of salt.

Dip each filet into the batter, then plunge into a pan with boiling oil.

When golden, remove the filets, draining the oil and drying on kitchen paper.

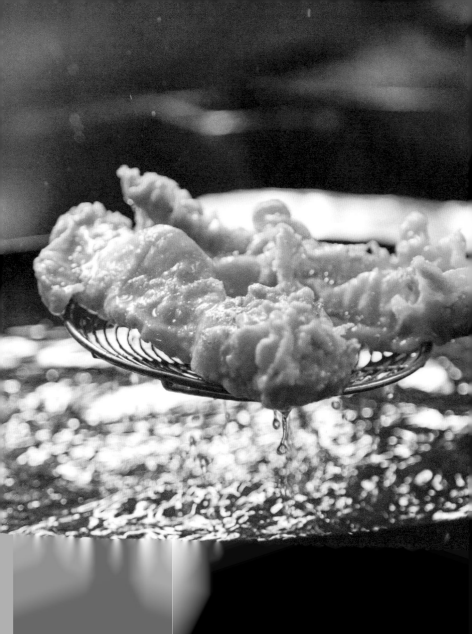

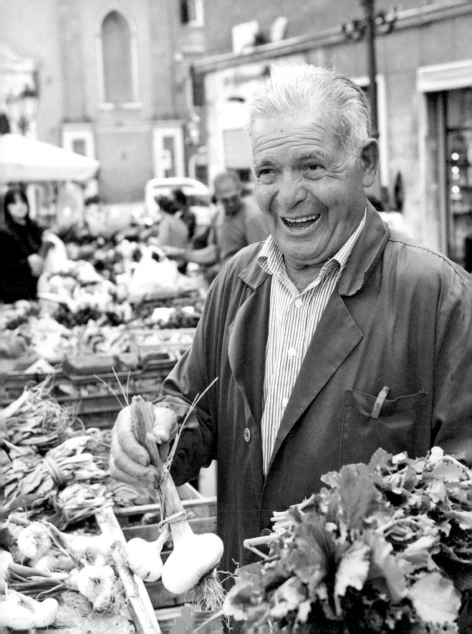

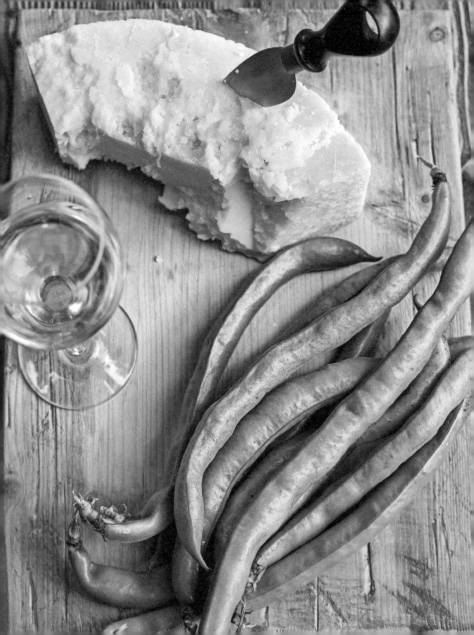

ARTICHOKES GIUDIA

Serves 4:
- 8 Romanesco purple
 artichokes
- extra virgin olive oil
- salt
- pepper

Clean the artichokes by removing the outer leaves and then the toughest part of the stem.

Cook in hot (not boiling) oil and when just cooked, drain on kitchen paper, arranging them with the stems turned upwards.

Lightly press down on the stems so the artichoke leaves open.

Season with salt and pepper and, as soon as they are cool, fry in hot oil for 2–3 minutes in a large skillet.

Remove the artichokes from the skillet and leave to dry on kitchen paper, serving while still hot.

■ ■ ■

For 6 supplì rice balls:
- 250 g (1¼ cups)
 Carnaroli or Vialone
 Nano rice
- 100 g (3½ oz)
 ground beef
- 200 g (7 oz) tinned
 tomatoes
- 1 onion
- 1 carrot
- 1 stalk of celery
- 2 eggs
- 1 mozzarella
- ½ glass of white wine
- vegetable stock (or
 hot water)
- breadcrumbs
- extra virgin olive oil
- salt
- black pepper

ROMAN-STYLE MIXED FRIED PLATTER

How to make the rice balls
Make the ragout with oil, chopped onion, celery, and tomato. Season with salt and pepper, pour in the wine and reduce.
Cook on a medium heat and when ready leave rest. Prepare the rice by cooking it directly in the ragout, diluting with the vegetable stock or hot water. Allow the cooking juices to reduce then move the rice to a large bowl and leave to cool after seasoning with salt and pepper.

Beat the eggs and dice the mozzarella. Prepare small balls with handfuls of rice, making a hole for the mozzarella and seal with more rice.

Dredge the rice ball in bread crumbs, then in beaten egg and then in bread crumbs again. Plunge the rice ball in a pan of boiling hot oil and remove when golden and crispy. Dry on paper towels and serve hot.

How to make the fried pumpkin flowers
Remove the stalk from the fresh flowers, without breaking. Wash and dry them carefully.

Chop the mozzarella and anchovy filets.

Ingredients for 12 fried pumpkin flowers:
- 12 pumpkin flowers
- 250 g (9 oz) mozzarella
- 5-6 anchovy filets in oil
- 140 g (1½ cups) flour
- 250 g (1 cup) still cold water
- oil for frying
- salt

Ingredients for 8 artichokes giudia:
See previous recipe

Fill each flower with some of this mixture and close carefully.

Prepare the batter in a bowl, pouring in the flour and then drizzling in the cold water, whisking well and adding a pinch of salt. Pour the oil for frying into a skillet and when hot, carefully add the flowers dredged in batter a few at a time.

Remove the flowers when golden and dry on kitchen paper. Serve hot.

For artichokes giudia, see previous recipe.

FIRST COURSES

TONNARELLI CACIO E PEPE

■ ☐ ☐

Serves 4:
- 500 g (1 lb) fresh
 tonnarelli pasta
- 300 g (3 cups)
 grated Pecorino
 Romano cheese
- plenty of freshly
 grated black pepper

Boil the tonnarelli, drain and set aside with
some of the cooking water.

Cream in a large skillet with the cooking
water and the cheese turning until smooth.

Sprinkle with plenty of black pepper.

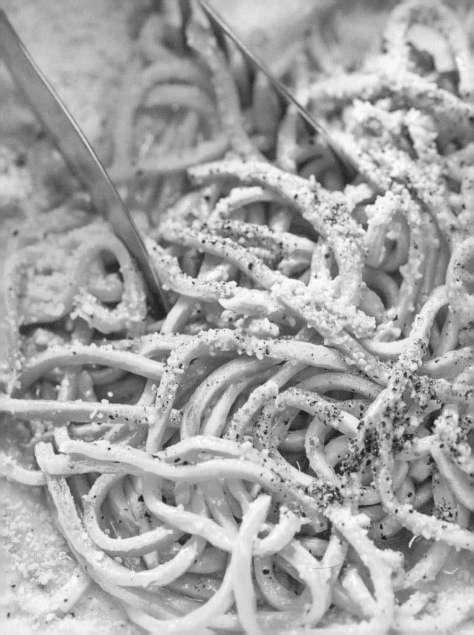

RIGATONI CARBONARA

Serves 4:
- 500 g (1 lb) rigatoni pasta
- 400 g (14 oz) pork cheek
- 4 whole eggs
- 400 g (4 cups) grated Pecorino Romano cheese
- plenty of freshly grated black pepper

Heat an aluminium or non-stick skillet and when hot toss in thick strips of pork cheek, distributing evenly.

After a few minutes, lower the flame and fry gently. Turn off the heat when the pork is very crisp and has lost all its fat.

Meanwhile, in a bowl mix in ¾ of the pecorino cheese with the eggs and freshly-ground pepper.

Cook the pasta, drain and pour into the skillet with the pork and a little cooking water. Toss the pasta, cream in the cheese and eggs, stirring to blend. If the pasta is too dry, add more cooking water; if it is too runny, add more pecorino.

Serve with a generous sprinkling of pecorino cheese and freshly-ground black pepper.

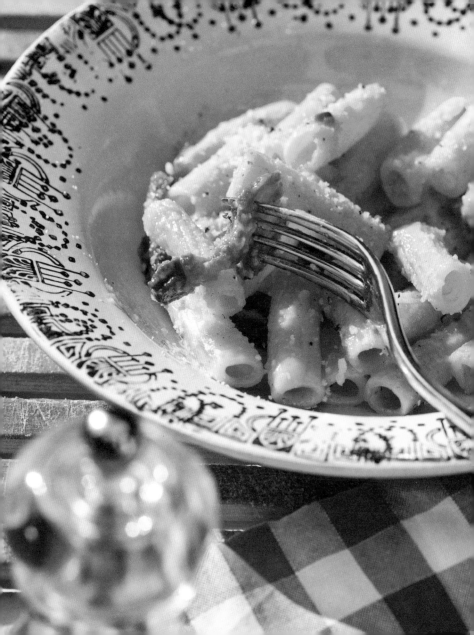

BUCATINI AMATRICIANA

■ ☐ ☐

Serves 4:
- 500 g (1 lb) bucatini pasta
- 200 g (7 oz) pork cheek
- 1 onion
- 500 g (1 lb) peeled tomatoes
- 150 g (1½ cups) grated Pecorino Romano cheese
- 1 glass of white wine
- 1 fresh chilli pepper
- extra virgin olive oil
- salt

Sauté onion and pork cheek carefully in a pan with oil.

Deglaze with white wine and add the peeled tomatoes and chilli.

Boil the bucatini in salted water, pour into the sauce and cream with plenty of pecorino.

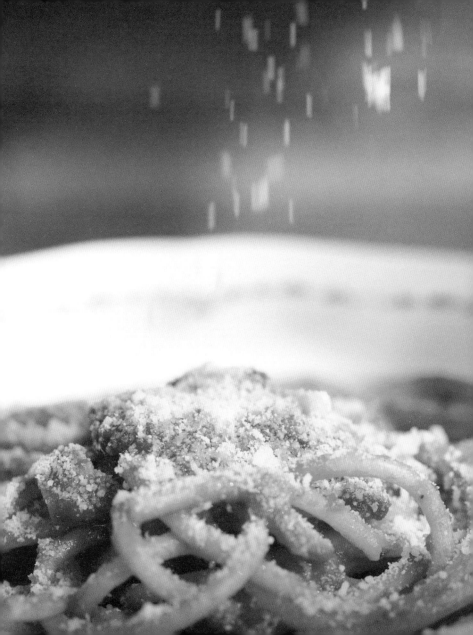

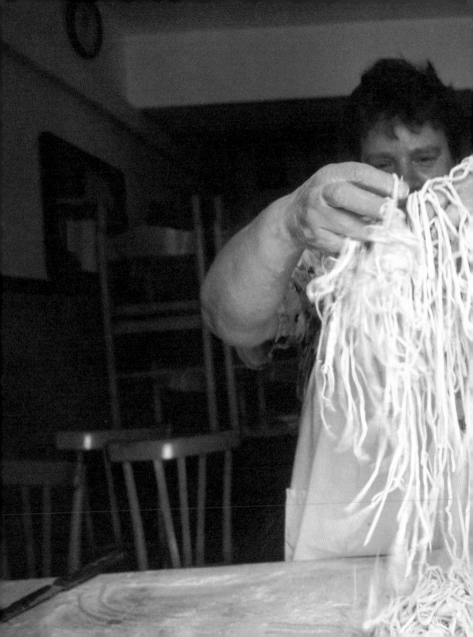

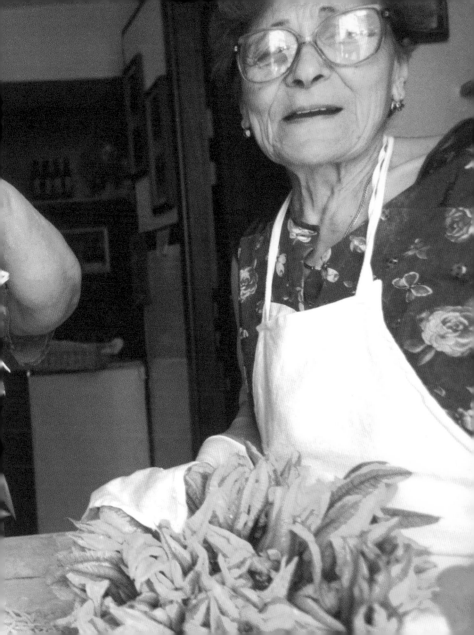

Serves 4:
- 400 g (14 oz) rigatoni or tortiglioni pasta
- vaccinara sauce *(see recipe on p. 58)*
- grated Parmigiano Reggiano
- salt

RIGATONI IN VACCINARA SAUCE

For the vaccinara sauce recipe, *see p. 58.*

When the oxtail is cooked, remove some sauce and pour into a pan.

Cook the pasta in salted boiling water.

When cooked, drain the pasta well, pour into the pan with the sauce and cream over low heat with a little grated Parmigiano.

Serve the pasta and sprinkle with another handful of Parmigiano.

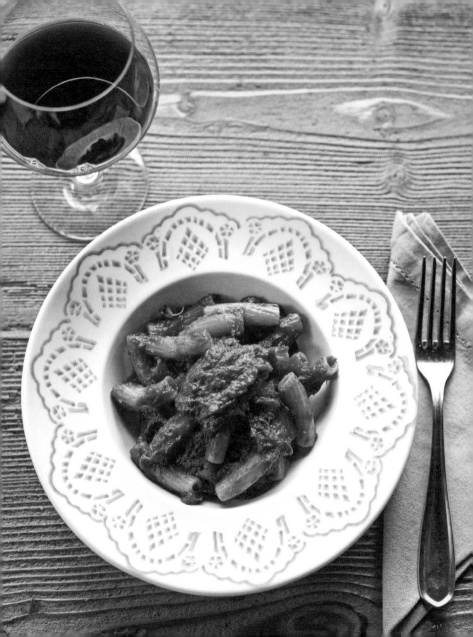

Serves 4:
- 400 g (14 oz) spaghetti
- 2-3 cloves of garlic
- 2 fresh chilli peppers
- 1 sprig of parsley
- 100 ml (6 tbsps) extra virgin olive oil
- salt

SPAGHETTI WITH GARLIC, OIL AND CHILLI PEPPER

Sauté garlic until golden brown in a large skillet with hot oil, chilli pepper and parsley, adding a pinch of salt at the end for extra flavour.

Cook pasta and drain it *al dente*.

Tip the pasta into the pan and sauté for a few minutes before serving.

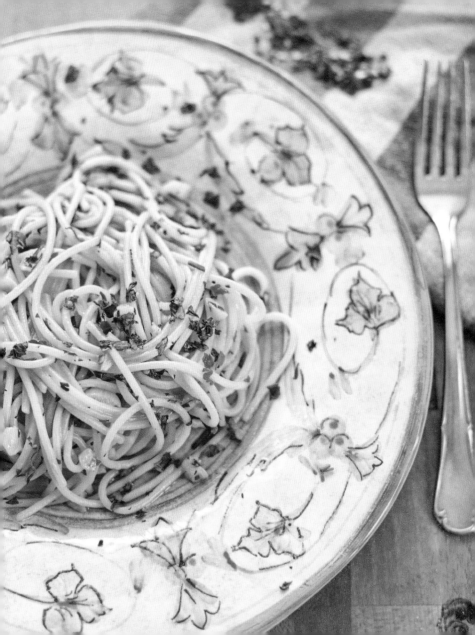

SPAGHETTI GRÌCIA

■ ☐ ☐

Serves 4:
- 400 g (14 oz) spaghetti
- 200 g (7 oz) pork cheek
- 60 g (8 tbsps) grated Pecorino Romano cheese
- extra virgin olive oil
- salt
- pepper
- chilli pepper to taste

Cut the pork into strips and brown in a skillet with oil over medium-low heat.Remove from heat when it starts to sizzle.

Boil the pasta in salted water, retaining a little of the cooking water.

Pepper the pork left aside and add a ladleful of pasta water to dilute the sauce.

Stir the pork into the pasta in a skillet of the right size for a couple of minutes at most.

Turn off the heat, add the Pecorino Romano, a sprinkling of fresh pepper and chilli pepper to taste.

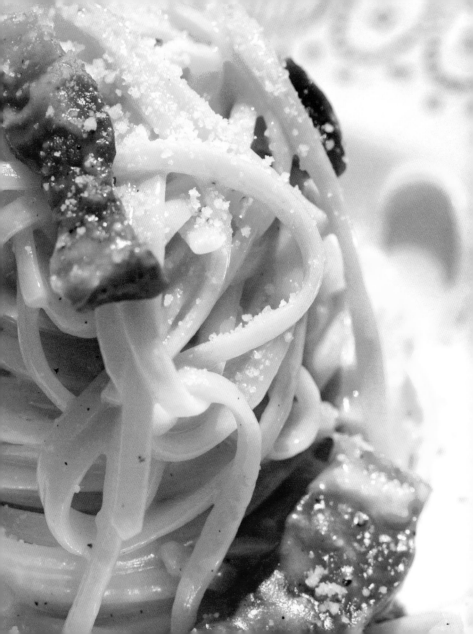

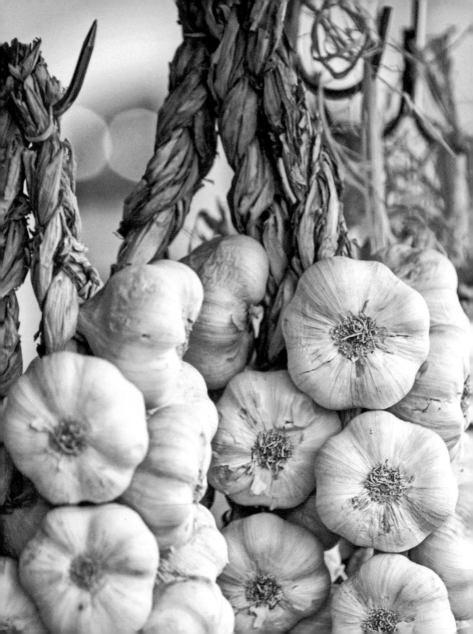

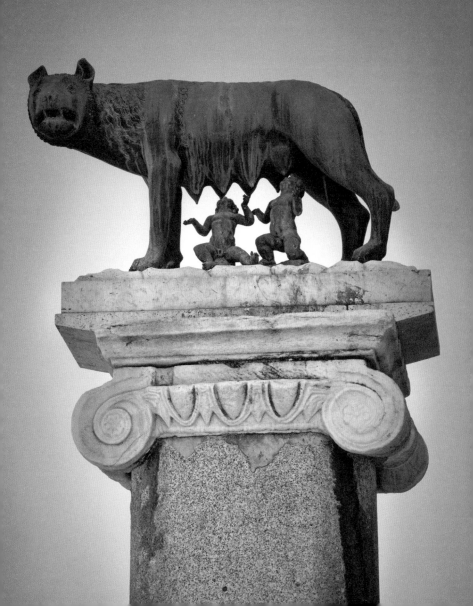

RIGATONI PAJATA

■ ■ □

Serves 4:
- 450 g (1 lb) rigatoni pasta
- 1 kg (2 lbs) lamb entrails wound in a loop
- 500 g (2 cups) tomato sauce
- ½ onion or scallion
- ½ glass red wine
- 1 clove
- extra virgin olive oil
- coarse salt
- pepper
- 200 g (2 cups) grated Pecorino Romano cheese

In a large, heavy skillet heat the oil and when hot, toss in the looped entrails, with a handful of salt, a clove and a sprinkling of pepper.

Leave to brown over a low heat, stirring often to prevent the entrails sticking. When well browned, add the half onion, finely chopped. Leave to fry again and then deglaze with wine. Cover the pan and leave on a low heat for 15 minutes.

Add the tomato sauce to the entrails, stirring with a wooden spoon, taking care not to break the loops.

After about an hour of cooking, still on a low heat and with a lid, the sauce is ready: leave in the pan for 15 minutes so the sauce is absorbed well.

Meanwhile, cook the pasta in boiling water and drain into the pan with the sauce and the entrails. Toss, blending in plenty of grated Pecorino and serve with even more cheese dusted over the top.

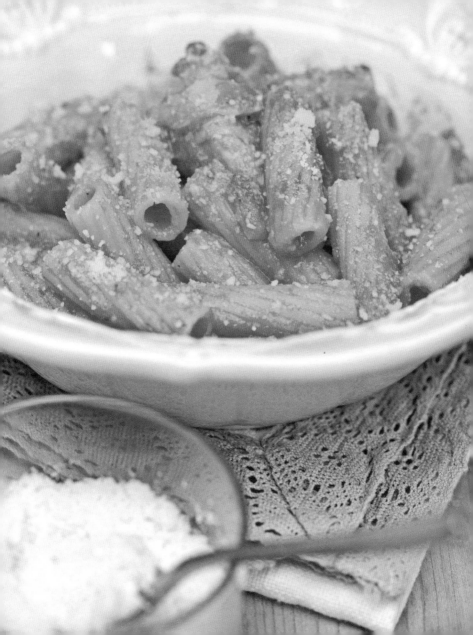

FETTUCCINE PAPALINA

■ ■ ■

Serves 4:
For the fettuccine:
- 400 g (4 cups)
 all-purpose white
 flour
- 4 fresh eggs

For the dressing:
- 150 g (5 oz) cured
 ham in one thick
 slice
- 150 g (5 oz) fresh
 or frozen peas
- 3 eggs
- 1–2 leeks
- 60 g (2 oz)
 Parmigiano Reggiano
- 100 ml (½ cup) milk
- saffron
- extra virgin olive oil
- salt
- pepper

How to make the fettuccine

Make a well of flour and break in the eggs.
Mix with fingers so the flour is absorbed
gradually.

When a smooth dough has been made, start
kneading on a lightly floured surface using the
palm of the hand. Pull and stretch for at least
10 minutes until the mixture becomes soft and
pliable.

Leave the pasta to rest under a damp towel
for 15 minutes.

Continue rolling out the dough on the floured
work surface to make it more pliable, being as
delicate as possible so it does not break.

Roll out the dough and leave to rest for
10 minutes.

Place the dough on a wooden cutting board
and roll up towards the centre from the top
and bottom edges, like a parchment, until the
two edges meet.

Cut the fettuccine in vertical slices.

How to make the sauce

Thinly slice the leeks and sauté in oil.
In another skillet with hot oil, add the diced
ham and after 1–2 minutes add the peas.

Break the eggs into a bowl, add the milk and
saffron, and stir to make frothy mixture, then
add the Parmigiano Reggiano.

Meanwhile, cook the fettuccine al dente, drain
and toss for a few moments with peas and ham.
Blend all the ingredients, add the frothy eggs,
milk and Parmigiano (using a spray like those
used for whipped cream) and then the sautéed
leeks.

Dust with ground black pepper and serve.

Serves 4:
- 8 large, firm red tomatoes
- 12 tbsps of Arborio rice
- 2 cloves of garlic
- 10 medium-size new potatoes
- basil
- extra virgin olive oil
- salt
- pepper

TOMATOES STUFFED WITH RICE

Wash tomatoes, cut off the top and remove the pulp.

Blitz the pulp and add finely-chopped garlic, basil, pepper, salt and rice, rinsed under running water.

Leave to flavour for at least an hour and a half. Drizzle with olive oil and fill the tomatoes with the mixture, then replace the tops.

Place the tomatoes and chopped potatoes in an oven tray with olive oil and bake for about an hour at 180 °C (355 °F). If the sauce reduces too much during cooking, add some hot water.

When done, salt the potatoes and serve hot. The tomatoes are tasty both hot or cold.

SPAGHETTI ALLA MASTINO

Serves 4:
- 400 g (14 oz) of spaghetti
- 4 squid
- 4 scampi
- 4 shrimp
- 500 g (1 lb) mussels
- 500 g (1 lb) clams
- 3 San Marzano tomatoes
- ½ glass of white wine
- garlic
- chilli pepper
- parsley
- extra virgin olive oil
- salt

Fry the chilli and garlic in the oil until just golden, add the tomatoes in pieces, salt to taste and remove before they are over cooked.

Add chopped squid, previously cleaned and washed; then the shelled mussels and clams. Toss quickly, then add the shrimp and scampi, and deglaze with white wine. Be careful not to overcook: the shellfish should be fleshy, just done and not too dry.

Cook the spaghetti in plenty of salted water and drained al dente, toss into the skillet and blend quickly.

Leave to rest for a few minutes before serving.

SECOND COURSES

PLUCK

■ ■ ◻

Serves 4:
- 600–700 g
 (1¼–1½ lbs) lamb
 pluck
- ½ onion
- 1 chilli pepper
- 2 artichokes
- white vinegar
- extra virgin olive oil
- salt
- pepper

Purge the lamb pluck (heart, liver and lungs) in water with a glass of white vinegar for 15 minutes, then rinse thoroughly and cube. Meanwhile, fry onion and chilli pepper in a skillet with oil.

Stew the pluck for at least an hour and for the last 5 minutes add the chopped artichokes.

Finish cooking, season to taste with salt and pepper.

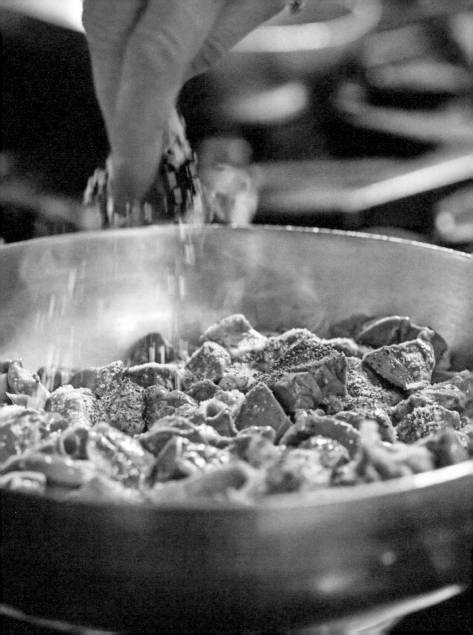

ROMAN-STYLE TRIPE

■ ■ ◻

Serves 4:
- 500 g (1 lb) tripe
- 4 peeled tomatoes
- ½ onion
- white vinegar
- extra virgin olive oil
- salt
- pepper
- a few leaves of
 spearmint
- grated Pecorino
 Romano cheese

Leave the tripe to purge in water and a glass of vinegar for 15 minutes, then rinse thoroughly.

Boil the tripe for an hour and a half and cut it into strips.

Sauté the onion for 2–3 minutes in a pan with oil, then add the tripe, peeled tomatoes, salt, pepper and spearmint.

Cook for 30 minutes and serve dusted with grated Pecorino cheese.

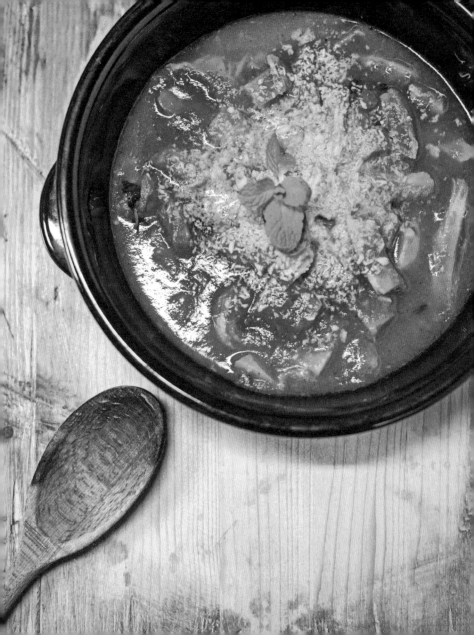

PAN-TOSSED TURNIP TOPS AND SAUSAGE

Serves 4:
- 1 kg (2 lbs) Roman turnip tops
- 500 g (1 lb) sausage
- 1 clove of garlic
- extra virgin olive oil
- salt
- chilli pepper to taste

Trim stems and spoiled leaves from the turnip tops, wash under running water, boil in salted water.

Meanwhile cook the sausage in a skillet, cut into pieces or whole if preferred.

Brown the clove of garlic in a large skillet, then add the turnip tops and toss for a few minutes. Add sausage, season with salt and pepper, and leave for about a minute to flavour.

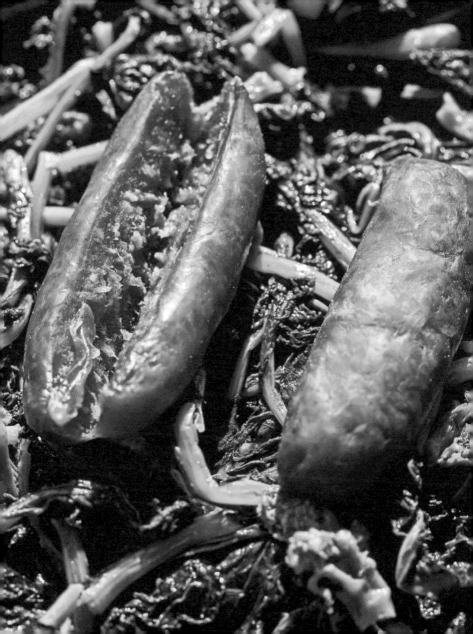

ROAST SUCKLING LAMB

Serves 4:
- 1 whole leg of suckling lamb with ribs
- 1 clove of garlic
- 2–3 sprigs of rosemary
- extra virgin olive oil
- salt
- pepper

Make slits in the lamb to allow seasoning to penetrate well, push sprigs of rosemary and slivers of garlic into the slits, then add salt, pepper and a little oil.

Roast the lamb for about an hour until golden brown and serve hot.

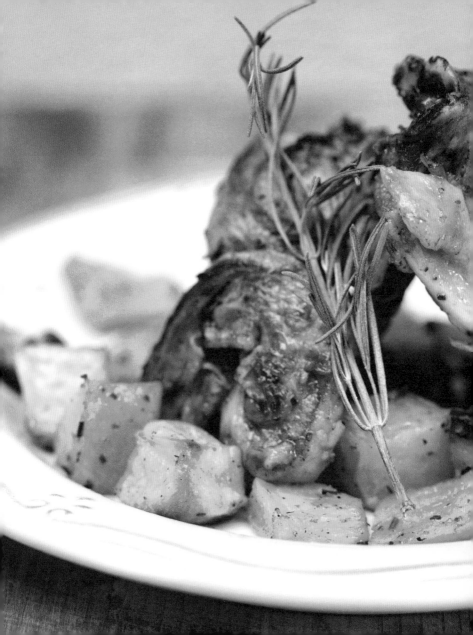

SALTIMBOCCA ROMANA

Serves 4:
- 8 slices finely-sliced lean veal
- 150 g (5 oz) cured ham
- a few sage leaves
- 1 glass of white wine
- ½ pack of butter
- extra virgin olive oil

Flour the meat slices, garnish with a slice of prosciutto and a sage leaf, fold and close with a toothpick.

Cook in a skillet with oil, butter and white wine.

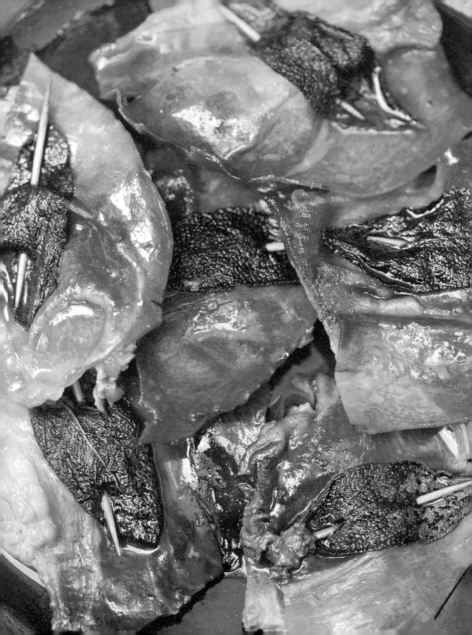

OXTAIL VACCINARA

■ ■ ■

Serves 4:
- 1.5-2 kg (3-4 lbs)
 defatted oxtail
- lard or pancetta
- 1 small onion
- 2 cloves of garlic
- 2 cloves
- 1 glass white wine
 (preferably Castelli
 Romani)
- 1.5 kg (3 lbs) peeled
 tomatoes
- 2 tablespoons of
 extra virgin olive oil
- salt
- pepper

For the sauce:
- celery to taste
- 10 pine nuts
- a fistful of sultanas
- grated dark
 chocolate

Carefully wash a large oxtail and cut it into pieces at the joints.

In a heavy-bottomed skillet brown the lard (or bacon) in oil, then add the chopped oxtail. When browned, add the chopped onion, garlic, cloves, salt, and pepper.

After a few minutes, sprinkle with a little wine and cover.

Cook for 15 minutes, add the tomatoes and cook for an hour, then add a little hot water, cover and cook slowly for another 5-6 hours, until the meat detaches from the bone.

Strip the celery of its filaments, boil, add to the sauce with the pine nuts, raisins and a little grated bitter chocolate.

Leave on the boil for 10 minutes and pour the sauce over the oxtail when serving, hot of course.

CHICKEN WITH PEPPERS

■ ☐ ☐

Serves 4:
- 1 chopped chicken
- 4 ripe yellow peppers
- 4 ripe red tomatoes
- 1 clove of garlic
- 1 glass of white wine
- extra virgin olive oil
- salt

Wash the chicken pieces and singe the skin of feathers to make it edible.

Heat the crushed garlic in a pan with oil, then add the chicken.

Leave to cook for 5 minutes, then add the white wine and leave to evaporate.

Add the peppers cut into strips and brown, then add washed, chopped tomatoes.
Add salt to taste and cover.

Cook for an hour and serve hot.

Serves 4:
- 800 g (2 lbs) salt cod
- 400 g (1 lb) sliced onions
- 4 tomatoes
- pine nuts, raisins, capers and Gaeta olives to taste
- extra virgin olive oil
- salt

SALT COD TRASTEVERE STYLE

The salt cod should be left to soak for 24 hours, replacing the water often.

Finely chop the onions and fry gently in the oil. Add the tomatoes to the onion and cook.

Skin and bone the salt cod filets, then reduced to boil in hot water for 15 minutes.

Drain and add to the sauce, cut into filets and leave to cook for another 10 minutes.

Serve in pasta bowls sprinkled with pine nuts, raisins, capers, and olives.

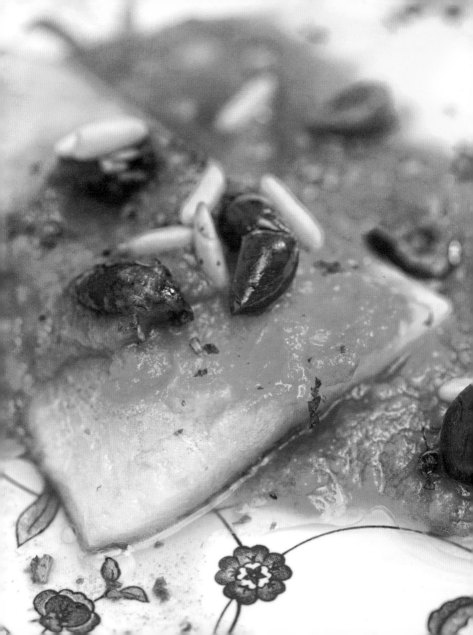

OX GAROFOLATO

■ ■ ■

Serves 4:
- 1.5 kg (3 lbs) ox topside or muscle
- 10 slices of pork cheek
- 8 medium tomatoes
- 2 cloves of garlic
- 1 small tub of cloves
- 1glass of dry white wine
- 1 tbsp of white lard or extra virgin olive oil
- 1 tsp fine salt
- 1 fistful coarse salt
- ½ tsp pepper

Make slits in the meat and insert chopped slices of pork cheek, then roll in a mix of fine salt, pepper and garlic.

Insert a clove in each slit.

Brown meat well in a pan with lard or oil, then deglaze with the wine, adding water, chopped tomatoes, cloves and salt.

Cover and seal with tin foil around the lid, adding a weight, then cook on very low heat for 3 hours.

Half an hour before the meat is done, check the density of the liquid and add salt. If the sauce is too thin, remove the meat and reduce without the lid.

When the meat has cooled, cut into slices, place in the sauce and heat up. Serve hot, preferably on warmed plates.

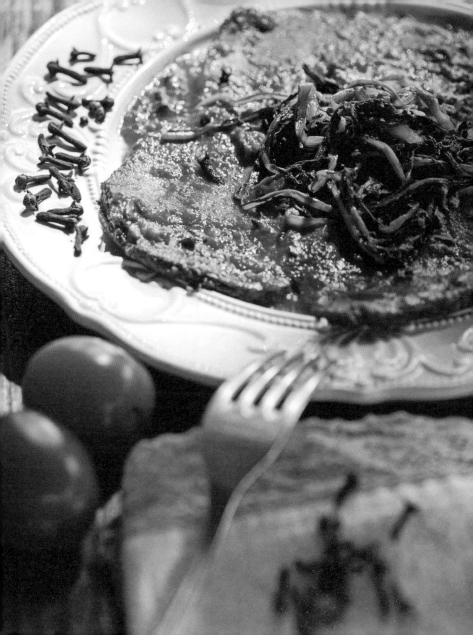

VEGETABLES

ARTICHOKES ROMANA

Servers 4:
- 4 artichokes
- 2 cloves of garlic
- 2 anchovies
- a few leaves
 of parsley
- a few leaves
 of calamint
- juice of 1 lemon
- 1 glass of white wine
- 1 glass of extra virgin
 olive oil
- salt
- pepper

Remove the outer artichoke leaves.
Leave the artichoke in water and lemon juice.

Chop garlic, anchovies, parsley, calamint;
mix and season with salt and pepper.

Arrange a layer of whole artichokes in a
saucepan and cover with the chopped
ingredients.

Drizzle with white wine and steam, covering
with straw paper.

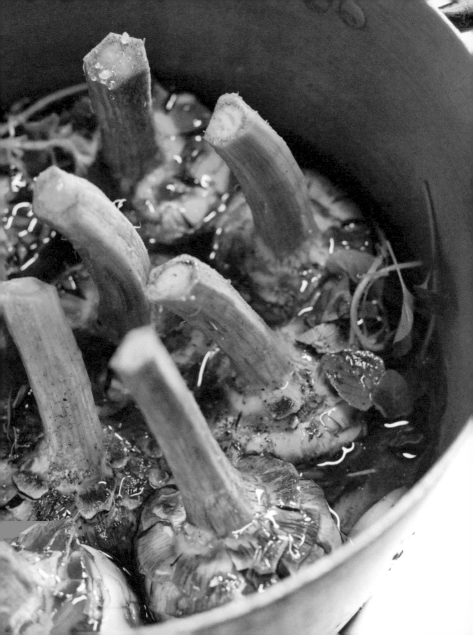

PAN-TOSSED CHICORY

Serves 4:
- 500 g (1 lb) chicory
- 2 cloves of garlic
- chilli pepper
- extra virgin olive oil
- salt

Thoroughly clean the chicory eliminating all traces of soil and rinse several times under running water.

Boil in plenty of boiling salted water until tender, then drain to remove all excess liquid. Brown the garlic and a hint of chiller pepper in a skillet with oil.

Add the chicory and leave to flavour for about ten minutes.

Season to taste and serve hot.

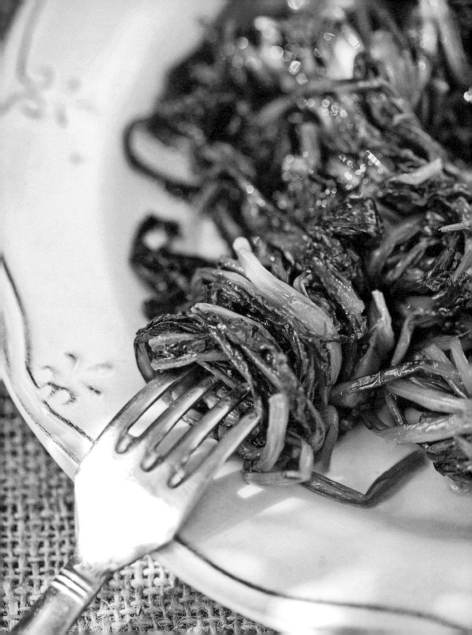

VIGNAROLA SOUP

Serves 4:
- 3 whole artichokes
- 200 g (½ lb) fava beans
- 200 g (½ lb) peas
- 1 onion
- 1 lettuce
- 2 slices of cheek pork, diced
- 1 glass of white wine
- salt
- pepper

Fry the cheek pork and onion in a skillet.

Add the artichokes (previously washed, soaked in water and lemon, cut into wedges), fava beans, peas and lettuce cut into small pieces.

Add the white wine, a pinch of salt, pepper and water, and boil for 20 minutes.

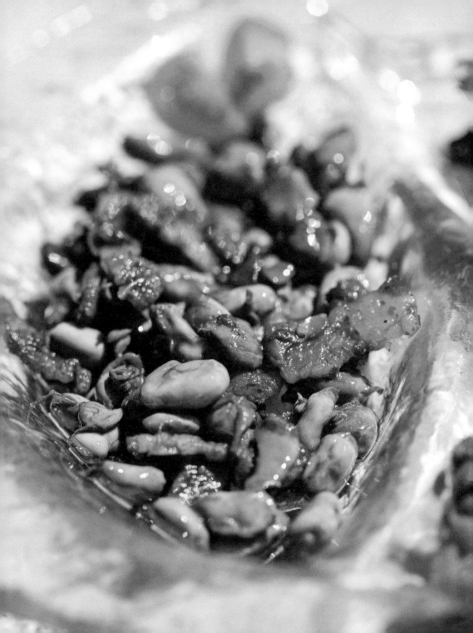

CHICORY TIPS ROMANA

■ ☐ ☐

Serves 4:
- 500 g (1 lb) chicory tips
- 4 anchovy filets in oil or a tube of anchovy paste
- 1 clove of garlic
- 4 tbsps of extra virgin olive oil
- salt
- pepper

Trim off the tougher end section of the chicory tips. Split the tips in half, in small strips.

Leave to soak in cold water for at least an hour to make them curl.

Aside, prepare a soft, smooth sauce by mashing anchovy filets into small pieces, or alternatively the anchovy paste, with oil, garlic, salt and pepper.

Drain the chicory tips well, pour into a salad bowl, drizzle with sauce and stir everything together just before serving to prevent the chicory tips blackening and softening too much (they must keep a crisp look).

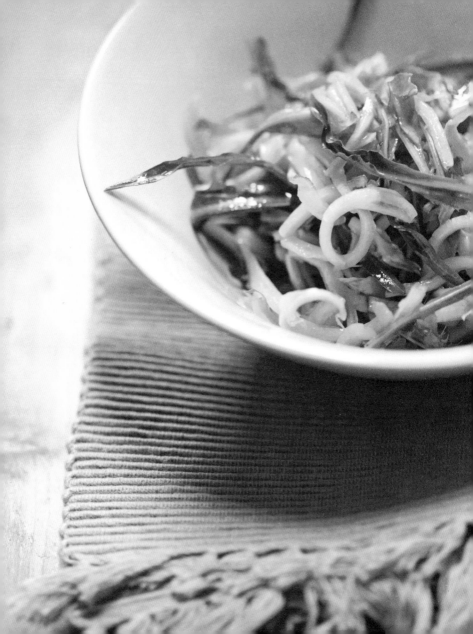

DESSERTS

ST JOSEPH'S BEIGNETS

■ ■ ▢

For 6 beignets:
- 180 g (2 cups) flour
- 200 g (1 cup) water
- 60 g (2 oz) of
 butter
- 20 g (1 tbsp) sugar
- 2 yolks and 3 whole
 eggs
- 1 sachet baking
 powder
- oil for frying
- salt

For the cream:
- 1 l (2 pints) milk
- 6 egg yolks
- 350 g (1¾ cups)
 sugar
- 160 g (1¹/₃ cups)
 flour

Boil the water, butter, sugar and a pinch
of salt for about 2 minutes.

Remove the pan from the heat, pour in the
flour and replace on heat, stirring until the
paste is ready. Pour into a large bowl and
leave the paste to cool for about 10 minutes.

Add eggs one at a time, then the baking
powder; then leave the dough wrapped
in a cloth to rest.

Prepare the cream by mixing all the
ingredients well. Pour the mixture in a pan
over a low heat and stir continuously until the
cream thickens; leave to boil for 5 minutes.
Leave to cool in a bowl covered with a kitchen
cloth. Insert a little dough at a time into a sac
à poche and squeeze out round beignets onto
a sheet of baking paper.

Heat a skillet with enough oil for frying.
When the oil is ready, tip the beignets off the
baking sheet of paper directly into the skillet.
Quite quickly the beignets will peel away and
start to brown.

When cool, fill the beignets with cream using
the sac à poche and dust with icing sugar.

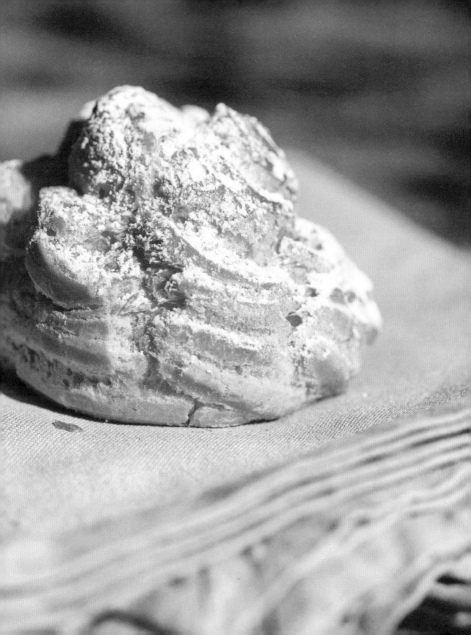

CASTAGNOLE

Ingredients:
- 300 g (3 cups) flour
- 60 g (3 tbsps) sugar
- 2 egg yolks
- 100 g (3½ oz)
 of butter
- 1 sachet of vanillin
- baking powder
 for cakes
- oil for frying
- salt

In a bowl, mix the sugar and eggs until the mixture appears frothy, then add the melted butter, flour, a pinch of salt, vanillin and baking powder.

Mix well to make a firm dough and leave to rest for an hour covered with a cloth.

When ready, roll out the dough and make small balls.

Fry in hot oil until brown, lay on absorbent paper and dredge thoroughly in a bowl of sugar.

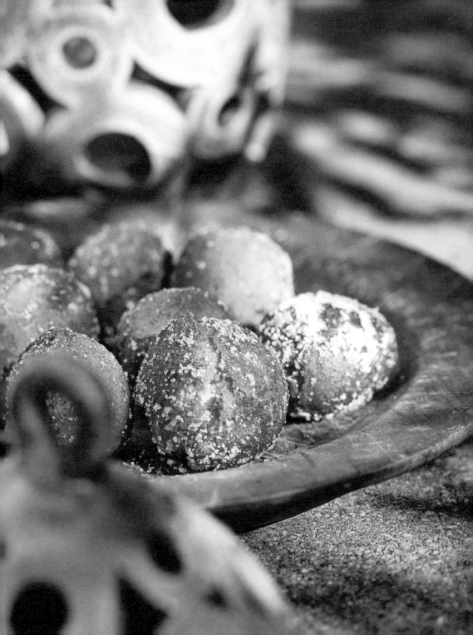

FRAPPE

Ingredients:
- 500 g (5 cups) flour
- 100 g (3½ oz) butter
- 100 g (½ cup) sugar
- 4 eggs
- baking powder
 for cakes
- oil for frying
- salt
- icing sugar

Pour the flour onto a pastry board with the butter at room temperature in the centre.

Stir slowly, adding the sugar, a pinch of salt, a pinch of yeast, and eggs, and work well to form a compact, springy dough.

Wrap in a tea towel and leave to stand for 2 hours.

Roll out the dough very thinly and cut small strips.

Fry the frappe strips in hot oil until golden brown and serve sprinkled with icing sugar.

MARITOZZO BUN WITH CREAM

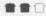

Serves 4:
- 100 g (1 cup) flour
- 2 eggs
- 25 g (¼ cup) extra virgin olive oil
- 25 g (1 oz) of butter
- 2 tbsps of sugar
- milk
- 10 g (3½ tsps) brewers' yeast
- vanilla flavouring
- salt
- whipped cream for filling

In a bowl work the flour, eggs, olive oil, a pinch of salt, butter, sugar, milk, baking powder, and vanilla flavouring to obtain a smooth dough.

Cover with a cloth and leave to rise for about 3 hours until the dough doubles in size.

Divide the dough and form balls, then pull into an oval shape.

Leave to rise again under a cloth then bake at 180 °C (355 °F) for 15 minutes.

Once cooled, cut open and fill with whipped cream.

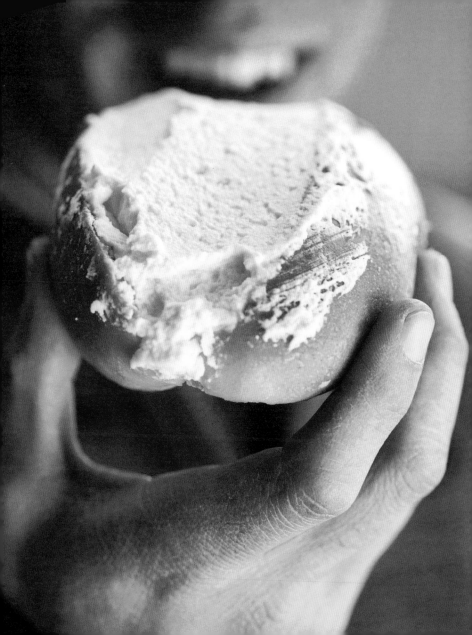

ROMAN PANGIALLO

■ ■ ◻

Serves 4:
- 100 g (¾ cup)
 peeled almonds
- 100 g (¾ cup)
 walnuts
- 100 g (¾ cup)
 chopped hazelnuts
- 50 g (5 tbsps)
 pine nuts
- 50 g (5 tbsps)
 candied fruit
- 150 g (¾ cup)
 raisins
- 100 g (1 cup) flour
- 100 g (1 cup) honey
- 75 g (3 oz)
 chocolate to taste
- grated zest of an
 orange and a lemon

For the icing:
- 1 tbsp flour
- 1 tablespoon oil
- ½ sachet of saffron
- water

Dissolve the honey in a small saucepan and add the orange and lemon peel.

Soak the raisins for 30 minutes or so.

Coarsely chop the nuts in a bowl and add the candied fruit, squeezed raisins and chopped chocolate.

Add the honey and stir, then gradually add the flour and stir again until the mixture becomes compact.

With floured hands form patties and leave to rest on a plate for a couple of hours.

Prepare the icing by heating in a small saucepan the flour, oil and saffron dissolved in a little water, pouring in more water to form a smooth batter.

Brush the rolls with the icing mixture and bake at 180 °C (355 °F) for 40 minutes until a glaze forms.

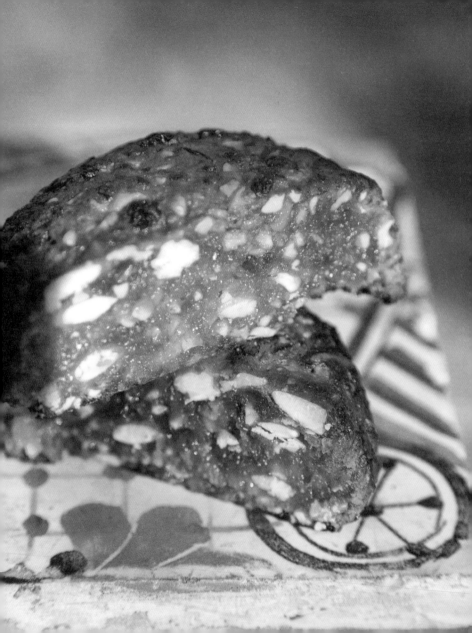

GLOSSARY

Amatriciana
"Amatriciana" condiment is named after the town of Amatrice, in the province of Rieti.

Cheek pork
Lard with a hint of lean marbling.

Fettuccine
Egg tagliatelle, fresh or dried.

Grìcia
"Pasta alla grìcia" named after the merchants from the Swiss Grisons or Valtellina.

Pajata (pagliata)
The highest part (duodenum and jejunum) of suckling veal intestines, cut into lengths and looped.

Pluck
The entrails of slaughtered animals (except intestine).

Provatura
Fresh spun-curd cheese similar to provola.

Romanesco artichoke

A variety of large purple artichoke that is very tender and without bristles. Perfect for the "giudia" recipe.

Suckling lamb

Young lamb not yet weaned.

Tonnarelli

Long egg pasta with a square section, cut with a special device called a "chitarra".

Cover and dish images are by **Barbara Santoro** except:

Stefano Amantini p. 6, p. 30-31
Tommaso Ausili p. 38
Matteo Carassale p. 16
Johanna Huber p. 91
Maurizio Rellini p. 2-3, p. 90
Anna Serrano p. 39
Luigi Vaccarella p. 10-11

Photos available on **www.simephoto.com**

Recipes by
Carla Magrelli
Editing
William Dello Russo
Translation
Angela Arnone
Photoeditor
Giovanni Simeone
Design
Jenny Biffis
Layout
Marta Amistani
Prepress
Fabio Mascanzoni

ISBN 978-88-99180-08-9

Sime srl
Tel. +39 0438 402581
www.sime-books.com

Edited highlights of:

"ROMA IN CUCINA
THE FLAVOURS OF ROME"

80 ricette della tradizione (e non)
80 traditional and non-traditional recipes

Recipes by Carla Magrelli
Photographs by Barbara Santoro

Hardback
Italiano/English
288 pages
19,5 x 23,5 cm
ISBN 978-88-95218-91-5
26,00 €

www.sime-books.com